JUST DRAW! FACES IN
15
MINUTES

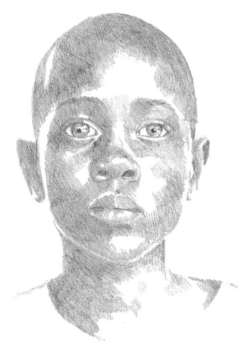

JUST DRAW! FACES IN 15 MINUTES

SUSIE HODGE

SIRIUS

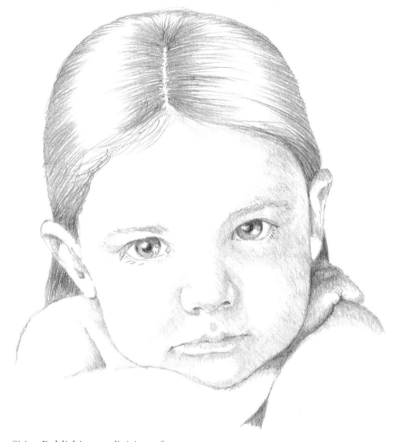

SIRIUS

This edition published in 2021 by Sirius Publishing, a division of
Arcturus Publishing Limited,
26/27 Bickels Yard, 151–153 Bermondsey Street,
London SE1 3HA

ISBN: 978-1-83857-615-8
AD006672UK

Printed in China

Contents

Introduction

Ask a child to draw a face and they'll do it with no qualms. Ask most adults and they'll probably freeze on the spot.

What happens when we grow up? What happens to our perceptions of the face and our confidence in our drawing abilities? It's complex, but from about the age of 11 we become more critical of ourselves and worry about looking foolish. It's not because we can't draw, but because we are thinking about it in the wrong way.

Acknowledging that, this book is here to help. It will encourage you to overcome misgivings and inhibitions, and it gives advice about drawing all types of faces – from different angles, in different lights, of different age groups and ethnicities, in various styles and using different materials.

Why make portraits?

Portraiture has been an important part of art in many cultures for thousands of years. The earliest known portrait is a tiny sculpture of a

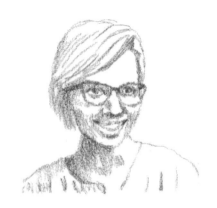

female head, carved 26,000 years ago from a woolly mammoth's tusk, found in what appears to be a woman's grave. From that time, the developments and differences in various cultures' interpretations and purposes of the portrait can be mapped over the centuries.

Before the invention of photography, a painted, sculpted or drawn portrait was the only way to record someone's appearance. Yet more than just a record, portraits have been used to convey various characteristics of each sitter, such as:

- Power
- Importance
- Virtue
- Beauty
- Wealth
- Taste
- Learning
- Sense of humour

Both creating and looking at portraits is a natural human inclination. Portraits inspire us to recall aspects of our past and our emotions, so faces remain among the most gratifying and fulfilling subjects to draw.

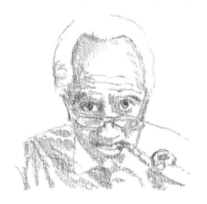

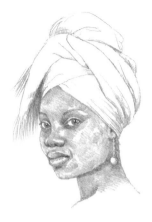

If you can write, you can draw

Like writing, drawing portraits is a method of making marks on two-dimensional surfaces. If you can write your name, you can draw, and if you can draw, you can draw faces.

This book will help you to build your confidence and draw faces convincingly. While

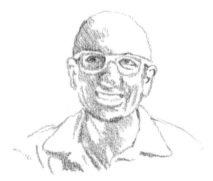

everyone's style and approach are different, certain things can be learned, and with these initial skills you can develop further, as much or as little as you like.

When you begin drawing, some things will probably feel awkward; your marks might be heavy or laboured, your proportions and

lines might not match what you see, and you might feel that you are not making progress, but persevere and you will learn what works for you – and what doesn't.

A lot of drawing relies on our perceptual skills and ability to be objective. Distances, dimensions and ratios have to be accurate for drawings to be compelling and convincing, and this book gives you methods and approaches to create accurate portraits. Once you learn some of these – such as measuring to attain correct proportions, how to identify and solve problems, and how to 'squint' to understand value relationships and tonal contrasts – you will be able to draw portraits with great confidence and accuracy.

Be patient!

More than anything, for accurate, convincing drawing, be patient! Take your time, and you will gradually develop an understanding of what kinds of marks work for you, how much pressure to use and where to place your marks, as well as what materials you like best.

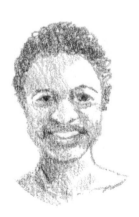

How to Use This Book

As the foundation of all art forms, drawing can be one of the most challenging and satisfying ways of expressing yourself, and, because faces fascinate us all, drawing portraits is especially rewarding.

History of portraiture

The ancient Egyptians created formulaic portraits, the ancient Greeks produced perfect – or ideal – portraits, and the ancient Romans added some elements of truth to these, such as a large nose, a heavy jaw, wrinkles or hooded eyes.

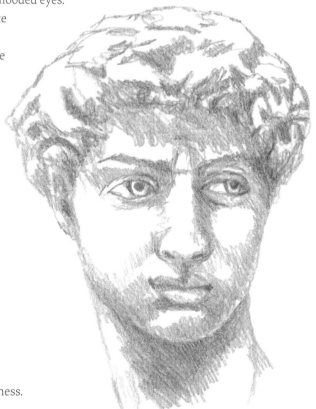

Centuries later, Renaissance artists produced naturalistic portraits that gradually became even more lifelike, as artists studied anatomy and gained an understanding of the bone and muscle structures of the face.

Portraiture continued as one of the most popular genres in art, and then after 1839 the invention of photography instigated further changes. Artists began exploring distortion and colour, creating images that could not be achieved with photography, such as conveying a sitter's emotions rather than just a physical likeness.

Draw, doodle and make notes!

This is a practical guide to help you draw faces with more confidence. Feel free to draw in this book, doodle on the pages and write notes. Use any materials you like, but choose a soft pencil if you want to erase your work. Follow the suggestions, projects and exercises, and don't worry about making mistakes.

Things to consider

Before you begin, there are two important things to consider. First, think about where you draw and your posture. Do you stand or sit? Do you hunch over your drawings with the light casting a shadow over them? If you stand, are you upright, or do you arch your back? If you sit, can you see your work without bending over and hurting your neck and shoulders? Good posture is particularly important.

Second, think about *why* you want to draw portraits and what you hope to gain or achieve from your artworks. Remember your purpose and remain motivated as you work on the projects. They will all help you to become a better portrait artist.

In this book

The book is divided into two parts, and is planned so that you can start drawing straight away. You can work chronologically, dip in and out, or pick up the book and put it down – whatever suits you best.

In the first part, there are practical exercises to help you gain confidence in drawing faces. Through doing them, hopefully over and again, you will rapidly improve your drawing skills. The structure of the first part is as follows:

• Suggested methods for quick sketches, with speedy warming-up ideas.
• Guidance about tone, including how to create accurate skin tones and give depth to your portraits.
• Anatomy of the face, looking at the structure of the head, including the bones and muscles.
• How to draw facial features – lips, nose, eyes and ears – and techniques for capturing emotion in people's expressions.

• Drawing hair that looks realistic and lifelike.
• Male and female differences in terms of head shapes, jawlines and overall proportions.
• How to draw children and babies, utilising the general rule, 'less is more'.
• Conveying depth and wisdom in older faces.

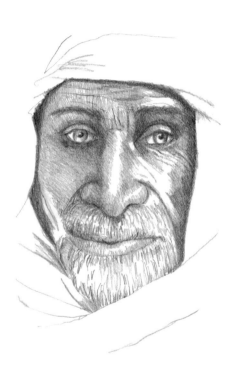

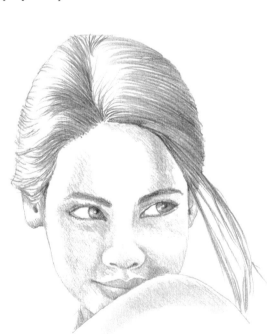

The second part of the book contains projects that you can practise and expand upon, and when you feel more confident, you can adapt the techniques you have used to create your own portraits. Examples include:

• Profile and three-quarter views.
• A baby.
• A smiling woman.
• A young man and an older man.
• A woman in a hijab.
• A laughing man and a man with glasses.

Some of the projects are quick, using loose and expressive lines, while others will take longer, with more details. Always remember that there is no particular or correct style of drawing portraits; we all draw in personal ways, and your own distinctive style will emerge as you gain confidence – which is achieved through experience and practice.

Improve your skills

It's up to you how much or how little you do. You might want to set aside a certain time each day, or week or month, or just draw as and when you can find the time. If you are really serious about improving your skills in portraiture, you'll need to draw often – as you are learning a new visual language.

Draw on your own, or enlist the companionship of friends and work through the book together. Arrange to meet once a week or month – in reality or online – to compare, discuss and maybe critique what you have each produced.

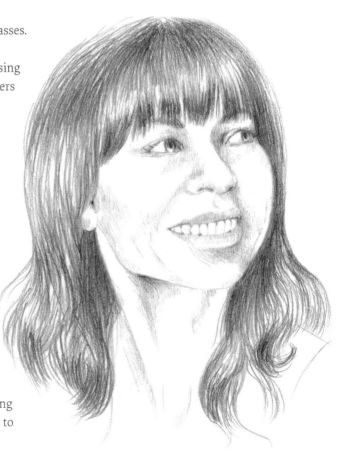

Quick Sketches

Drawing should never feel boring, because you are always learning and your results constantly evolve. Quick sketches are a great way to start.

First, choose your materials – consider pencils, charcoal, fine liners or ballpoint pens, for instance. Everything will affect how you draw; some materials are more suited to particular techniques. Experiment and discover what you enjoy using. Try a range of different materials as you may be surprised at what suits you best. So if you've never tried charcoal, have a go; if you only use HB pencils, try using a 3B or 4B. A range of soft pencils is perfect for building up lines, shapes and tones; many of the drawings in this book are made with B, 2B, 3B and 5B pencils.

Warming up

Beginning with some simple lines and shapes will improve your control, which will make your work more fluid and dynamic. Here are some ideas to help:

1 *Hold your drawing implement firmly, but keep your wrist fairly flexible and draw lines; make them wavy, curving, long or short. Let your marks flow.*

2 *Draw some straighter lines. Hold your*
 pencil, pen or charcoal firmly on your
 drawing surface and flick across. Keep
 your hand off the paper. Use firmer
 and lighter pressure to create a sense of
 darker and lighter tones.

3 *Draw some rounded shapes – ellipses.*
 Make these different sizes and work
 quite quickly – you are not aiming for
 perfect shapes, but you want fluidity.

Warm up below

4 *Doodle! Feel free to work across a piece of paper, a page in your sketchbook or the margins of this book. Make as many contrasting marks, lines and shapes as you can. Create simple shapes; randomly sketch anything you like. Doodles come in any shape or form, and in any colour, so feel free!*

All of these exercises should be fun and relaxed. Like exercises for toning the body, you can do them at any time and they will simply improve your final outcome.

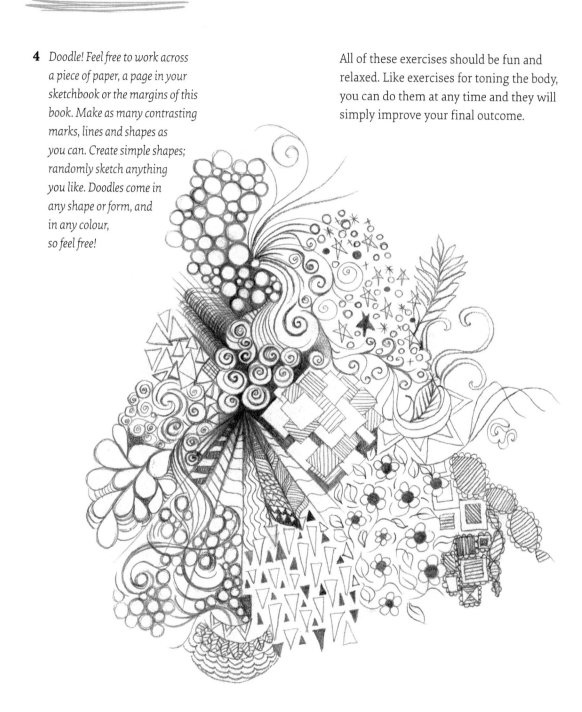

Do some doodling here

Seeing

As with any drawing, portraits rely on your ability to really see; that is, to draw just what you see and not what you *think* you see. So often with all of us, our memories and thoughts can interfere with our drawing; we tend to put marks in certain places that are actually incorrect.

So one of the first skills you need to cultivate is the ability to *see*. This means being objective; observing clearly so that no preconceived ideas subconsciously emerge in your drawings, and you instead make marks based on exactly what is in front of you. Once you have done this a few times, it will become second nature to 'shut out' your inner voice that's telling you what the face looks like. Measurements and proportions will all be helpful, but always start with your eyes and really look carefully.

Gesture drawings

Sometimes called scribbled drawings, gesture drawings are a great way to improve your drawing skills. They are done in short, timed periods, from 20 seconds to 5 minutes, using fast, expressive lines. They capture basic forms and proportions with little detail.

The purpose here is primarily to study the human head and face, learning how features are connected and to get into the rhythm of drawing faces with features in the right places. As you don't have time to copy what you see accurately, you have to make quick decisions about what marks to make and what to ignore.

Use inexpensive paper as these won't be your neatest drawings, and move your drawing arm fluidly. It is best to work with something smooth, such as soft or firm pencils, or ballpoint or felt-tip pens. Don't erase anything; if you make a mistake, learn from it and move on to the next drawing.

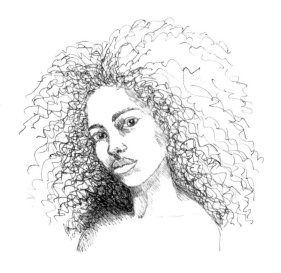

Practise here

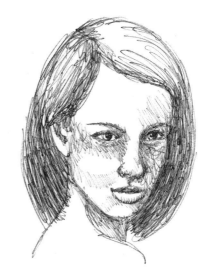

Continuous drawings

Try making a continuous line drawing without lifting your drawing medium from your paper. Your own head is a good subject for this exercise, but change the angle from which you draw it. As with gestural drawings, continuous line drawings will develop your confidence and drawing speed, and encourage your eyes, hand and brain to work together. To do them properly, stop thinking!

1 *Place your pen or pencil on the surface and do not remove it until the drawing is complete. The line can become thicker and thinner, but it should never break.*

2 *Work speedily; as you observe, move your line. Leave any imperfections.*

3 *Create several drawings like this in one go, using different tools if you can.*

Draw your own here

Quick head sketches

Try drawing any or all of the sketches of heads you see here, or draw your own – you can copy them from photographs, but even better, draw people around you.

Each day, draw a self-portrait – just a quick one; look for face and eye shapes, angles and shadows. Make it at least A5-sized, and use whatever materials you like. See what you can do in 15 minutes.

All adult heads are different, but they all have similarities. Here are some basic things to look out for when drawing faces, but remember that these are all just rough indications, as all face shapes vary.

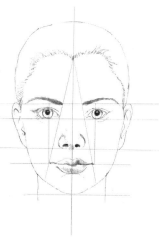

Heads are roughly egg-shaped with the tapered end as the chin.

The eyes are approximately halfway between the top of the head and the chin.

The edges of the nostrils align with the tear ducts of the eyes.

Eyes are about one eye-width apart.

The width of the head from the front is about five eyes wide.

The tops of the ears align with the eyebrows; the bottoms of the ears align with the bottom of the nose.

The mouth is about two-thirds up from the chin; the corners of the mouth line up with the pupils.

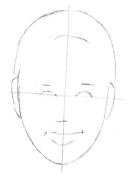

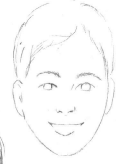

Necks are usually thicker than you think, and ears are generally bigger than you expect!

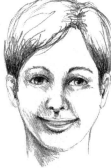

Draw your own here

Sighting method

To measure a face that you are looking at, the sighting method can be extremely helpful.

1 *Press your spine against the back of your chair and hold a pencil vertically in your hand between your thumb and fingers. Extend the arm that is holding the pencil forward. Keep this arm straight and rigid, and close one eye.*

2 *Align the tip of your vertical pencil in your extended arm with the top of the head you are drawing. Move your arm down and mark this on your paper.*

3 *Then go back to exactly the same position, your back flattened against your chair, arm extended, pencil point aligned with the top of the head and slide your thumb down the pencil to the chin. Mark this distance between the tip of the pencil and your thumb on your paper. You now have the measurement of the top of the head and the chin for your drawing.*

4 *For your next measurements, do the same with the width of the face and continue in this way, turning your pencil to gauge different measurements across the face, always keeping your back straight, your extended arm rigid and the same eye shut.*

Use the sighting method to draw some heads here

Tone

While there is no right or wrong way to draw faces, there are certain effective methods that can help you achieve skilful likenesses. Whether you are drawing from life (recommended) or from photographs (which have limitations but are a good starting point and often all that is available), tone – or light and shade – will help you to create solid-looking heads. Tonal contrasts can change a flat-looking face into a three-dimensional one. So if you want to create a lifelike, convincing illusion, then you need to learn to draw the effects of light, or tones, on your subject.

Tone is the relative scale of light to dark values in an image. It is vital for creating an appearance of depth and solidity in a drawing. When we look at a person's head and face, the tones we see are made up of:
• The local tone or colour of the skin.
• Shadows and highlights, depending on the angle and intensity of the light source.
• Reflected light and shade. Shadows often fall in similar places because of the planes of the face; around the eye sockets and nostrils, for instance.

Before you begin

When you are setting up a model, first consider your lighting. The face should show contrasts between light and shade. After you have lightly sketched in the basic shapes of the head and features, look at the tones. Where are the brightest highlights? Where are the darkest areas? These may not be where you expect; people assume that the eyes or teeth will be the brightest parts of the face, but these are usually a little shadowed with just tiny bright dots of highlight.

Squinting

Half-closing your eyes will help you to blend away small details and see larger shapes and areas of tone. By squinting, you eliminate the details of the features and see only the darkest tones. Notice three main tonal contrasts: the darkest tones, brightest highlights and mid-tones. As a general rule, work from dark to light, and use a light touch – you can always go darker, but not lighter.

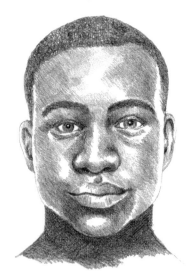

Creating tones and marks

By using just five different types of shading – blending, gradating, hatching, crosshatching and stippling – you will be able to build up quite a repertoire of tones and textures that ultimately can be used to make your portraits appear three-dimensional, and to create the look of hair, skin, clothing and so on.

Blending

To create the appearance of smooth skin or shadows and straight hair, for instance, use uniform blending, either rendering in straight lines or in small circles, layering if necessary.

Gradating

To create smooth changes from light to dark, apply the lightest pressure and then gradually become firmer with more layers to create greater depth. You can also shade from dark to light, starting with firmer pressure and gradually becoming lighter.

Practise here

Hatching

Draw parallel lines – close together for deeper, darker shading, and further apart for lighter. Use a sharp point for ultra-fine hatched marks, and softer, wider strokes for less detailed hatching. You can press harder for deeper tones.

Crosshatching

This begins with hatched lines in one direction, then more in the opposite direction. Once again, the closer together or darker the lines, the darker and deeper the tones will be.

Stippling

This is created with dots – close together for darker tones, further apart with fewer dots for lighter. Depending on how uniform or otherwise your marks are, the shaded area will seem either smooth or bumpy and uneven.

Practise here

Creating depth

The head is rounded, so light falls on it in similar ways as it falls on a ball. Try drawing circles and applying some basic shading to show where the light falls and where it does not; in other words, make a flat circle look like a three-dimensional sphere. This will be the basis for your shading on a head.

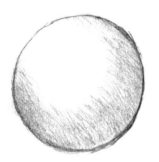 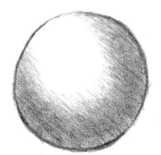 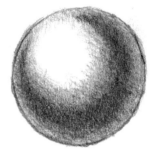

Practise here

Anatomy of the Head

The next few pages look at the bones and muscles of the head and neck, and we also examine the ways in which foreshortening affects our perception of the shape and proportions of the head.

Bones

It helps when drawing faces to be aware where the bones hold the face out and up, like scaffolding – mainly on the forehead, cheeks and chin. The eye sockets are deep, the jaw and teeth are strong. The head is widest across the temple and cheeks. The nose and ears are made of cartilage, not bone, but when drawing a face, this is not apparent.

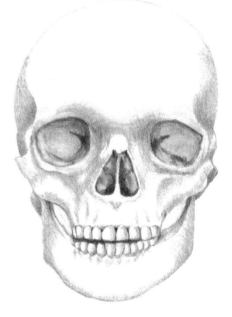

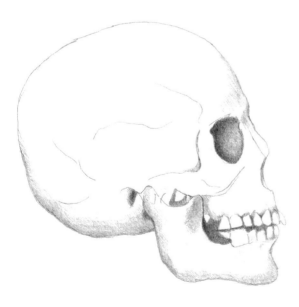

The skull is made up of the rounded cranium that houses the brain and the organs of sight and hearing. Below this, the facial block contains the maxillary, or the central part of the head, with the nasal bone, eye sockets and upper teeth. Below this is the mandible, or the lower part of the jaw and chin; it is the only mobile bone of the skull that is hinged at the sides of the upper skull, just below the ears.

Muscles

The muscles on our face enable us to eat and drink, speak, cry, sneeze and more. Expressive or dynamic lines or wrinkles occur along facial muscles. On young people's faces, these lines in the skin disappear when the muscles relax, but as people age, many of the lines remain as static or permanent wrinkles.

No face is symmetrical. Yet while every face varies, there is still a pattern of proportion, with particular characteristics and proportions common in certain ethnicities, sexes and age groups. The shapes, proportions and anatomical physiognomies of every individual face gives each of us our individuality and character, and the ways in which we use our muscles is one of the aspects of the face that conveys our personalities.

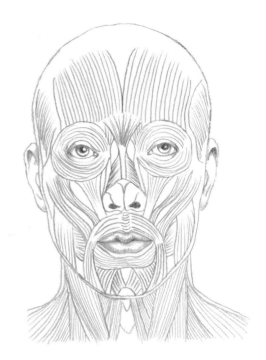

Practise here

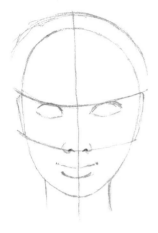

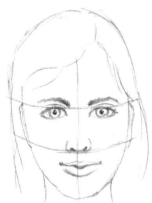

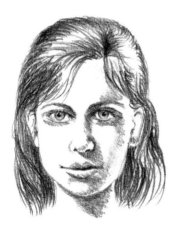

Proportion

Once you are familiar with the measurements on page 18 and ways that the face sits and moves due to underlying bones and muscles, this bit will be easy, but at first, begin by observing your model carefully, sketch the oval-shaped head and then draw guidelines: a vertical line in the centre (remembering that the face is rounded, not flat) and then two guidelines to position the eyes and nose. Continue to refine your drawing by adding the features and hair.

Practise here

Foreshortening

When seen from dramatic angles, foreshortening affects the shape of the head and facial features. Parts of the face that are closest to your eye look bigger than parts that are further away, and proportions and perceived shapes change.

Look at different faces from various angles to become familiar with the ways in which features seem to change shape and prominence. You will probably notice how certain bony areas protrude – not just the nose and the ears, but also the eyebrows, cheekbones and perhaps the mouth and chin, while the eyes and sides of the mouth tend to sink in slightly.

When foreshortening the face, always start with the largest sections first. Look at tilted and turned angles, and notice how distant features appear much smaller than closer features. Use the space opposite and overleaf, or fill a few pages of a sketchbook with foreshortened heads.

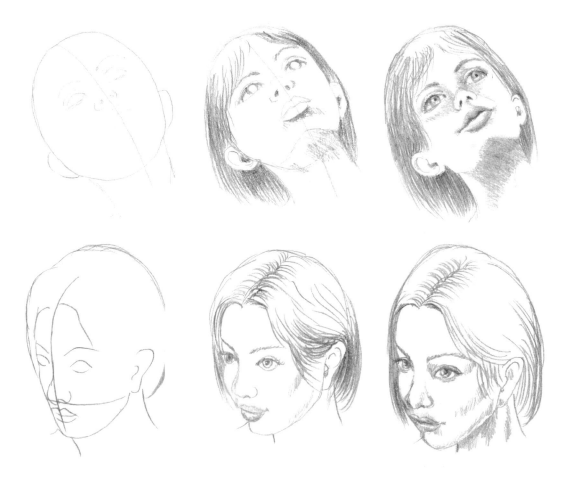

Draw your own here

Practise here

Putting it all together

Over the next pages, various aspects of heads and faces are discussed and explored. You'll find tips about observations on features, drawing hair and differences in male and female faces, as well as changes as we grow from babyhood to old age. To pull all this together and draw an accurate likeness, concentrate on the shapes in and around the face; that is, between the features, in the hair, the cheeks and so on. Is the forehead or nose broad, the eyebrows arching, the lips thin or full? Do the teeth protrude, is the chin rounded or square? What aspects of the face strike you when you first look at it – the shape and angle of the eyes, the corners of the mouth and shape of the lips, whether or not you can see the nostrils from your viewing angle? Look for the play of light and the shapes made by the shadows.

Overall, try not to overdraw; a suggestion of a line or shadow is often far more powerful than heavy lines. Allow viewers to interpret what they see, which can only be done when your drawing is hinted at rather than tightly delineated. Be sparing with your marks where possible; plan to sketch rather than create an analytical drawing.

Features

Although you need to create an accurate likeness through the facial features, many people focus too strongly on these when they are starting to draw portraits. So a balance is needed. Draw across your whole drawing; don't concentrate too much on any one area. Check back regularly over shapes, angles and proportions. The features are important, however, so here is a quick run-through of things to look out for with each facial feature.

Lips

Most lower lips are fuller than top lips. Lips also move a lot; they stretch when smiling and purse when kissing or drinking through a straw. The easiest and quickest way of drawing them is with three lines:

• A central line for a closed mouth. This is the darkest line.
• A lower line indicates the lower lip and often has shadow beneath it.
• A top line above marks the top of the upper lip. This should be drawn lightly or it will appear cartoony. You can also simply create the top lip with some gentle shading.

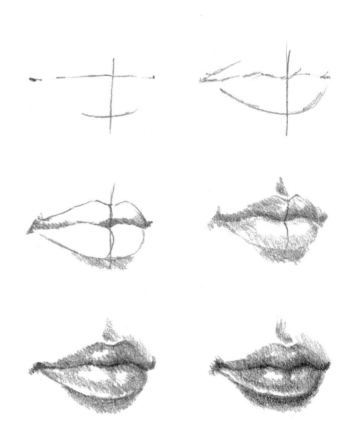

In profile, the lips come to a point at one side and have two curves on the other side, rather like a heart on its side.

There are differences between male and female lips. Female mouths are more defined, while the edges of male lips are more subtle, better described by shadows around them rather than the edges themselves.

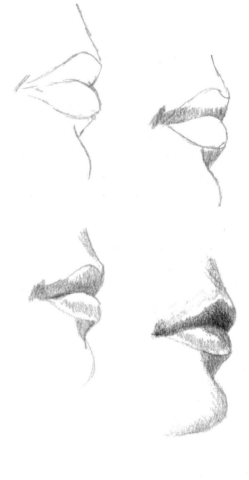

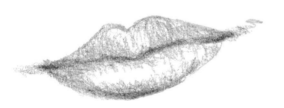

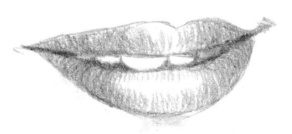

Teeth

Mouths are more difficult to draw when the teeth are showing. Don't try to draw every tooth, as this can make the mouth look crowded, and never draw a hard line between the teeth. Instead, draw them generally, without too many lines, and apply some soft shading to show that they are three-dimensional. As the teeth recede into the mouth, the shadows become darker.

Practise here

Noses

A protruding wedge, the nose is far less mobile than the lips and eyes. Some noses are close to the top lip, and the tip of the nose can either tilt upwards or downwards.

It helps to draw three circles; these make up the tip of the nose and the two nostrils. Add a shadow under the tip and cast shadows under the bottom edge of the nose. For tonal contrasts, the nostrils – if they can be seen – are dark, as are the curves around the sides of the nose. Some nasal ridges are prominent and bony, others are sunken, and nostrils can be wide or narrow.

When seen face-on, the sides of the nose should be conveyed with tonal contrasts rather than lines, but the bottom of the nose –that is, around the nostrils – can be drawn as lines with gentle shading.

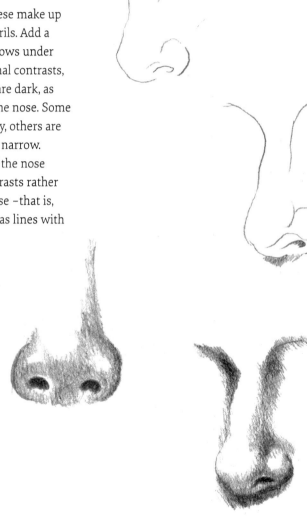

Practise here

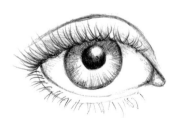

Eyes

Notice that the eye is set back from the bridge of the nose because it is in the eye socket. The brow and nose protrude from the face to protect the eye. The skin around the eyes is finer than most other places, so is usually quicker to show the signs of ageing. However, this aspect must be treated carefully or your portrait could look heavy-handed. Not everything needs to be shown; often just a suggestion is more descriptive than too many lines.

Eyelids can also change with age, and upper eyelids vary hugely. Always remember that the eyeball is spherical, so the white is often

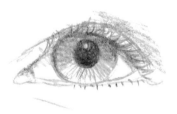

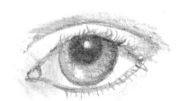

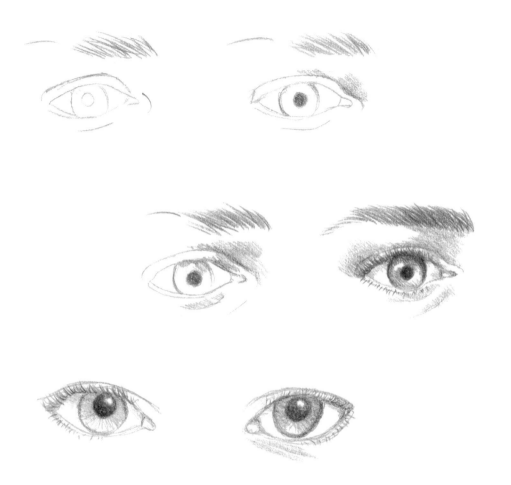

shaded slightly. In profile, the eye can be seen as a segment of the ball, like a triangle with one curved side. The iris and the pupil are perfect circles when the eye is looking straight at you. If turning away or looking up and down, they become ellipses. The top eyelid covers the iris, but the bottom contour of the iris remains visible. The pupil is the darkest part of the eye. Render

it with smooth shading, leaving an area for a highlight, but not too big in the pupil and the iris. Notice the direction of growth of eyelashes and eyebrows – and like hair and brows, don't try to draw every lash; just draw enough to give a general overall impression.

Have a go on the next page.

Practise here

Ears

Made up mainly of cartilage with soft lobes at the bottom, ears are often described as resembling shells and are usually flat to the side of the head. They are quite complex to draw, so if you are drawing a profile portrait, look for shadows and highlights rather than every linear detail. Notice that all the shapes and shadows are curving; there are no straight lines here. Ears vary from face to face; some people have hanging lobes, while others have lobes that are connected to their face.

More than anything, drawing accurate, lifelike faces is about placement: where you put the features, including – extremely importantly – the spaces between.

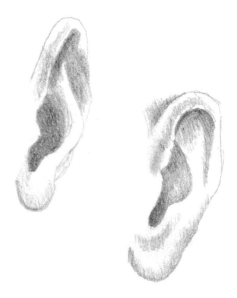

Practise here

Emotions

Although most portraits you draw will probably be either smiling or impassive, it's worth understanding how to portray different emotions as sometimes you might want to draw these when they are either being shown overtly or discreetly.

Emotions can be conveyed through two or three facial areas such as the eyebrows, eyes, nose or mouth. In general, the more areas of the face involved, the more intense the emotion. For example, if you wanted to show mild anger, you might only express it in the eyebrows while leaving the rest of the face neutral. To show strong anger, you would narrow the eyes and clench the mouth. You can also blend multiple emotions by mixing the expressions. For example, you can blend anger with sadness by combining an angry brow with a downturned mouth. Certain emotions blend more naturally with others.

These are the six universal facial expressions: surprise, fear, disgust, anger, joy and sadness.

Surprise

Eyebrows are raised, eyes are opened wide and the jaw drops, parting the lips. The lifting of the eyebrows can produce horizontal lines across the forehead.

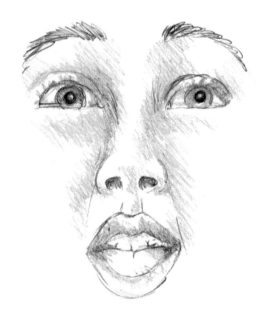

Fear

Similar to surprise, the brows also lift in fear.
Unlike surprise, however, with fear the inner
corners of the brows are drawn together.
There are usually horizontal lines across
the forehead, but these are shorter than
those shown in surprise. The lines are more
concentrated in the middle. Lips in fear are
more tense than in surprise.

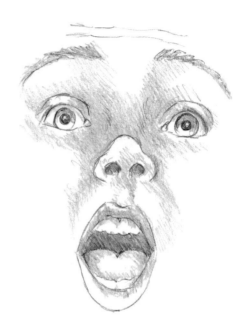

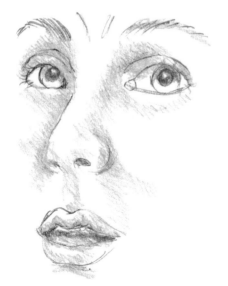

Concern

This is a subtle change from fear above.
Most visible in the mouth, nose and
frown lines, the upper lip is raised, the
mouth is slightly open, and the eyebrows
remain flat. Imagine that the person is
not gasping, but is slightly opening his
or her mouth and frowning slightly
between the brows.

Anger

In anger, the eyebrows are drawn down and together. Add vertical wrinkles between the eyebrows. Eyes also widen and the lower lids tense. The mouth can either be pressed shut or opened with the teeth showing. Lips are tense.

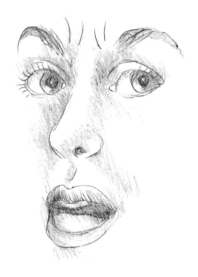

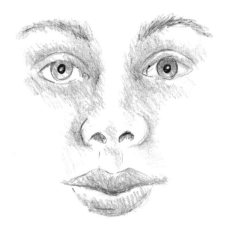

Calm

A reposed, but nonetheless alert facial expression, here the corners of the mouth are drawn back, the cheeks are flattened and the eyes and eyebrows are static. Most shadows are in the centre of the face.

Determination

The outer corners of the mouth are clenched into the cheeks and the eyebrows slightly raised and drawn down at their outer ends. The centre of the mouth forms almost a straight line and the upper eyelids raised.

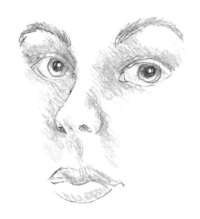

Practise here

Creating expressions

These children are examples of how you can bring it all together, combining what you know about muscles and bones, and also proportion and foreshortening. Note, for example, how the jaw moves with the mouth and that lines appear when the eyebrows are raised or pulled together – even on children's faces. Like the rest of the body, facial muscles mainly originate on bone, but unlike the rest of the body, they pull on the soft forms of the face, including the skin, eyebrows, eyelids and mouth, creating facial expressions.

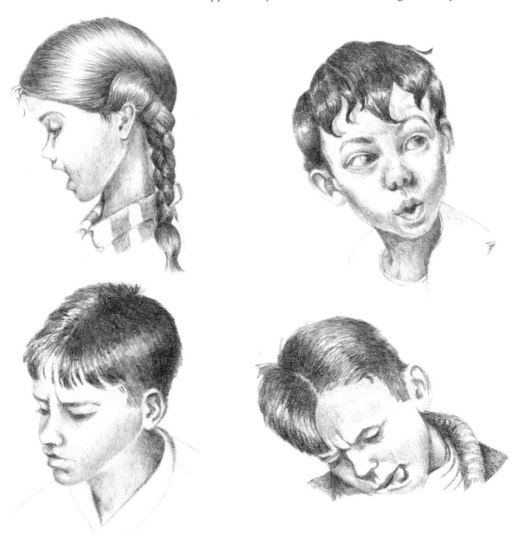

Practise here

Facial plane drawings

Simplify your drawing by eliminating
details and breaking down the shapes
into a few basic planes. Use one light
source to accentuate the planes. In
the drawings here, the light source is
above and to the left of the head. This
lighting defines the features by leaving
shadows under the eyebrows, nose,
upper lip and chin.

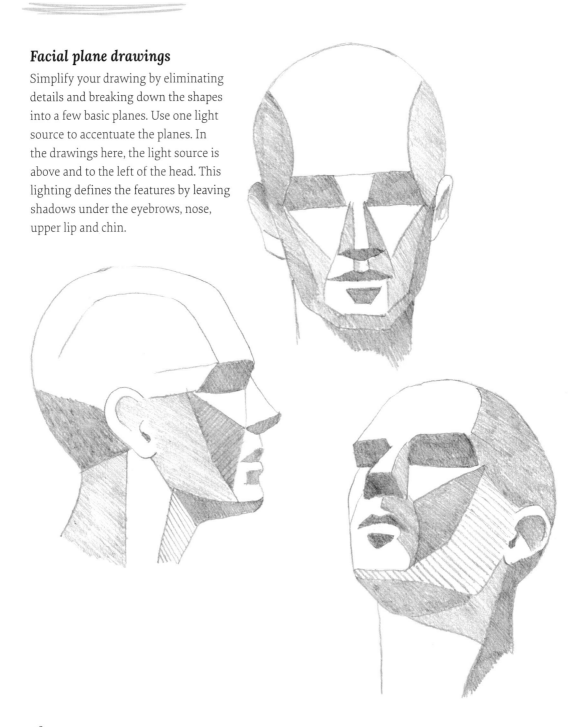

Practise some facial plane drawings here

Try drawing the head in simple planes in different positions. Leave out details and features, and just become used to the angles of each part of the face.

Hair

Many things contribute to portraits being lifelike and convincing, and one of the first things we notice about people is their hair. Hair can also help to convey a person's age group, character, personality, tastes, ethnicity and gender. So to create a lifelike portrait, you need to draw hair as accurately as possible, or at least to give a realistic impression, and to know what to leave in and what to omit. Often, especially with people who have long hair, this is the largest part of a portrait. The most important things to concentrate on when drawing the hair are:

• The overall shape.
• The direction of the hair, or its flow, which can be affected by style.
• Tone – where are the darkest and lightest areas?
• Texture – the general feel and appearance of the hair.

Depending on its length, texture, thickness, shape and colour, hair can completely alter the appearance of the face.

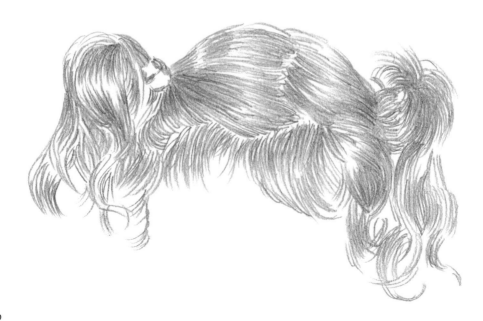

Tips for drawing hair

1 Before you do anything, look at where the hair is placed and its overall shape, or mass. Is it low on the forehead, pulled back, spiky, a mass of curls or short? Consider all this and sketch a basic, light guideline; you are simplifying the whole thing. Be as objective as possible and just draw what you see; be aware of negative shapes – or where the hair is not. Notice where it is full, where it tapers, its length, whether you can see the ears and how much neck is showing. Is the hair smooth, wavy or curly, short or long? If it helps, break it down into several simple shapes rather than one large one.

2 Add individual strands or wisps of hair that break it up and make it 'real looking'. Notice – and mark on – where there is a parting or fringe, and so on.

3 Now start drawing general lines in the direction the hair goes – if it is straight, these lines will be straight;

if it is curly, draw wiggly lines; and if the hair is wavy, draw curved lines. Don't try to draw every single hair, but create a general idea of the masses of darks and lights, and make sure that your marks flow.

4 Squint your eyes to see where the darkest and lightest tones are. Begin drawing the darkest tones, but don't press too hard; you can always layer later to make these areas even darker. If you are using white paper, leave this bare to show as highlights, and if you are using a pencil or pastels and you accidentally cover the lightest areas, use an eraser (putty eraser with pastel) to lift and lighten.

5 Some types of hair do not have such pronounced shine; for instance, grey or white hair, frizzy hair, or dreadlocks or afros.

6 Vary your lines and marks, but always draw them in the direction of growth or style.

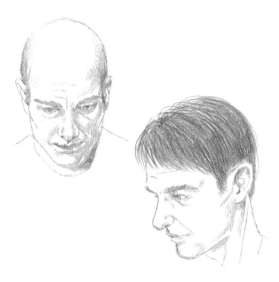

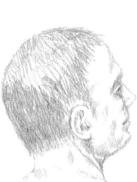

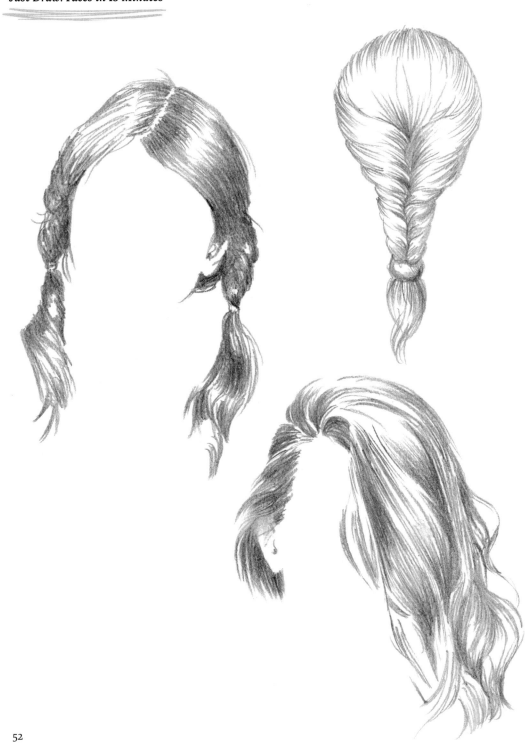

Practise here

Draw some different types of hair here

Things to note:
- The direction of hair can change in areas, so notice where this occurs and draw lines accordingly.
- Draw the hair in sections as this can be helpful to break it down when you are faced with a whole head of hair, which can be daunting. Just remember if you do this, go over the entire head once you have finished, to make sure none of it looks unbalanced.
- Notice how dark the darkest areas are, even in white or pale blonde hair, such as at the roots or behind the ears, and how light it is, usually on the top. Shadows and highlights are an essential part of conveying a lot of hair realistically. The effect of deep shadows and bright highlights is known as chiaroscuro, and was used to great effect by artists such as Caravaggio and Rembrandt.
- Generally, you are only defining the position and shape of the hairs, not every individual hair.
- Drawing hair is about positive and negative

drawing, so keep looking at the negative shapes to make sure your positive shapes are correct.
- Curved lines convey a feeling of flowing hair, and to reinforce this flow and improve the accuracy of your drawing, look for rhythms in the lines and tones, to create a fluidity. Always vary your lines in the hair – some will be heavy and thick, others light and fine.
- Most types of hair – but not all – have clear-cut highlights, half-tones and darker shadowed areas. They also have texture, such as smooth and shiny or uneven and more matte.
- For some portraits, you will perhaps only want to make a suggestion of hair, with few details; for others, you will want to include more details. Be careful that you are never too heavy-handed, or you could end up flattening the whole image.

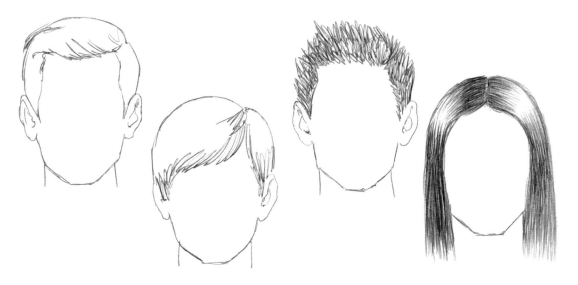

Facial hair

Another essential feature of a natural-looking portrait, facial hair must be viewed as a series of shapes or marks, although you should draw some individual hairs. Apply varied and directional marks, some dark, some lighter, closely following what you see. Be fairly sensitive about what you draw and what you ignore; you are aiming to show individual strands, but not each one; work quickly and keep the marks short and varied.

As with hair on the head, first of all block in the mass or shape of the overall facial hair, whether this is a beard, moustache or whatever. You might need to use an eraser to lift out some highlights and a sharp point to add a few details. Eyebrows can be bushy, heavy, fine, arched,

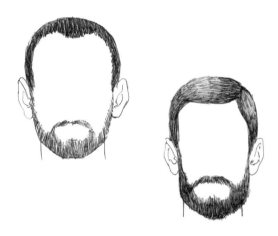

straight, light, tame or messy, and they add character to a face, so pay close attention to them. You can draw a light outline for the whole shape, but always draw them with several individual short lines in the direction of growth.

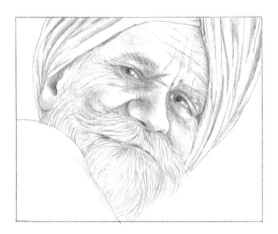

Note: While it's always best to draw from life, photographs and other static references are great for practice, and they often show you clearly where the darks and lights fall in the hair.

Draw some different types of hair here

Male and Female Differences

While this section might seem at first glance sexist, stereotypical and contradictory or denying or ignoring different genders, there are general methods for making male and female faces look more masculine or feminine, and these will be the most common genders that most people draw. Of course there are always discrepancies and every individual face is distinctive, but some features, shapes and proportions instantly convey either masculinity or femininity.

For instance, men generally have longer and larger faces than women, and male faces often seem squarer, with longer jawlines, while women have softer, more rounded features and smaller chins than their male counterparts. More angular lines suggest a male face, while women generally have curved lines rather than straight. If you're not sure about this, look at Saint John in *The Last Supper* of 1495–98 by Leonardo da Vinci. Dan Brown wrote an entire book based on the notion that Saint John in this fresco, sitting next to Jesus, was in fact Mary Magdalene. In truth, the image is a representation of the male Saint John, but looking at the image, it is easy to see why he could be mistaken for a she; he's petite, with a small, soft, delicate face shape and features.

Further instances of common male and female characteristics include thicker eyebrows for men and thinner, more tapered brows for women. Some shaped (plucked, waxed or lasered) eyebrows look a little contrived, so be careful with these. Also be aware that different trends in eyebrow shapes could date your portraits, so it's probably best to play down aspects like this.

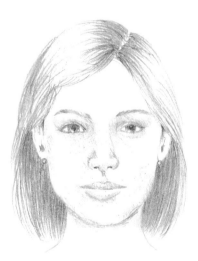
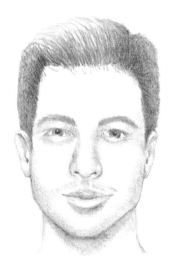

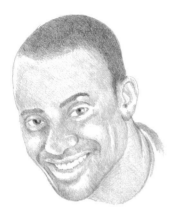 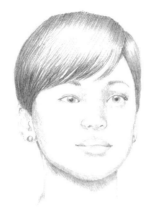 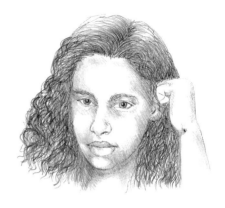

The following are some tips to make your portraits look either more feminine or masculine, but first and foremost always follow the appearance of the person you are drawing.

As with face shapes, everyone's eyes are unique, but whatever the actual shape of an individual's eyes, emphasize the curved, oval shapes for women and more rectangular shapes for men. Female eyes tend to look slightly larger than male eyes because their brows are slightly higher and more arched. Male eyes have a more deep-set appearance, and the eyebrows are usually straighter and bushier than female eyes. Give a female face longer lashes and barely apply lashes at all for most men.

For a feminine-looking nose, focus on the rounded shapes of the nostrils and tip, while draw with more chiselled lines and shapes for men. Male noses are usually larger and slightly more prominent than female noses, and the bridge is usually straight or slightly arched. Male noses occasionally appear slightly crooked, but this can

Practise here

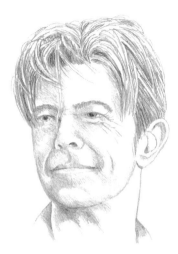

Generally, a woman's neck is slimmer than a man's, and in men the Adam's apple is prominent. Don't emphasize this too much or – just as with a hard outline on a mouth – you'll end up with a cartoon-like drawing.

Facial hair, as in beards, moustaches, sideburns and so on, instantly make a portrait look more masculine. Hairstyles are generally different for men and women, so these also give instant clues. Male hairlines often recede more than women's.

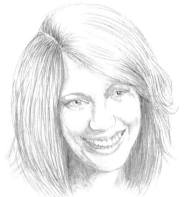

give the nose a greater sense of character. Female noses are usually smaller.

Cheekbones are often more angled for male faces and rounded for females. Female cheeks tend to be more prominent and contain more fat deposits, giving them a rounder, fuller look than male cheeks. Male cheeks usually have a sharper, angular appearance and lie flatter on the face.

Similarly, female lips are often fuller than male lips. They can be darker with more defined upper lips for women, while for men you can sometimes barely draw the upper lip at all; often just shade the indent below the nose, although the bottom lip has to be drawn, albeit with a light touch. Male or female, most bottom lips can be defined with a dark shadowed patch directly beneath it.

Male chins have a squarer and more angular appearance than female chins. Males also have a heavier and wider jawbone than females. Female chins are usually more rounded and delicate.

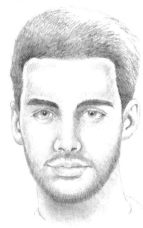

Draw some male and female faces and features here

Children and Babies

Most babies and children have bright, large eyes and chubby, rounded cheeks. The eyeballs at birth are not full-sized, but the iris and cornea are larger in proportion to this size, which creates a doll-like appearance. Lips are small, soft and rosy. By around eight months old, a baby usually has two central lower incisors; by twelve months, four upper incisors; by eighteen months, the other two lower incisors; and at around two years old, the canines and remaining teeth have appeared.

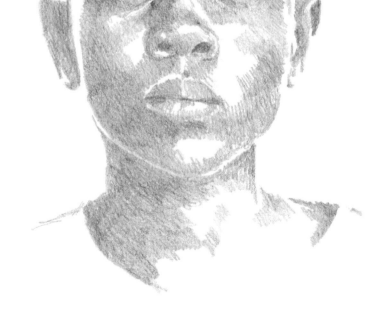

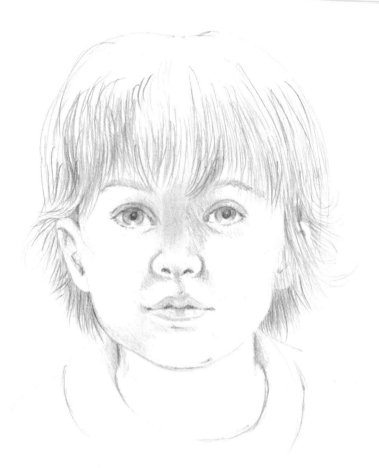

The growth and loss of teeth from babyhood through childhood can help you to make a characterful portrait. A baby's forehead is proportionately larger than an adult's, and as they grow, the face enlarges and the forehead becomes smaller in proportion to the rest of the face.

A child's cranium differs from an adult as it is elongated and oval, widest between the forehead and the back of the head, especially just above the ears. The forehead usually protrudes, while receding and flattening at the eyebrows. The bones of the face are small. The neck is thin and short in comparison with the size of the head. A child's skull is thin and elastic and proportions are markedly different from adults'.

From babyhood to adolescence, great changes take place in the face. It lengthens and the nose and cheekbones become more prominent. The teeth add width and depth to the lower part of the face, jawbones become more angular, the masseter muscles are more in evidence, and the chin takes on a particular shape.

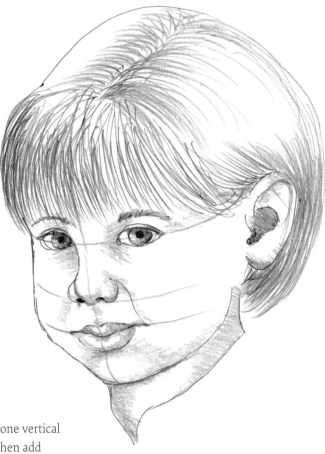

A *minimum of marks*

Measuring lines can be helpful. Draw one vertical line running straight down the nose, then add as many light horizontal lines as you wish, to help you to place each feature. With babies and particularly young children, the eyes are about two-thirds down the head. Work on smooth paper if you can, as rough surfaces can make it difficult to achieve the smoothly modelled tones and delicate features necessary. Work slowly and carefully using a fairly soft pencil, or if you're using other materials, make sure you use a fine point. Work lightly – you can always layer later for greater depth and definition. Less is always more with children and baby faces, so work with a minimum of marks.

Children and babies have soft, clear, fine skin, so your shading should be extremely light-handed. Even with dark-skinned babies and children, build shading and tones sparingly; you can always add more later. Highlights are important; create a general idea rather than including too many details, and the most important features to focus on are the child's eyes and soft hair. Often, you can leave the middle of the lower eyelid white to act as a highlight which will help to brighten the eyes and give them a natural gleam. If not, as with adult eyes, leave the smallest highlight in the pupil.

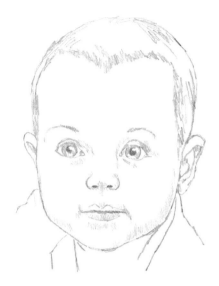

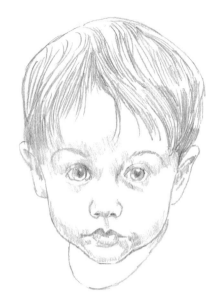

Practise here

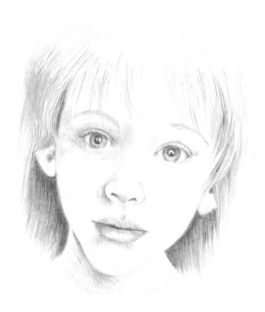

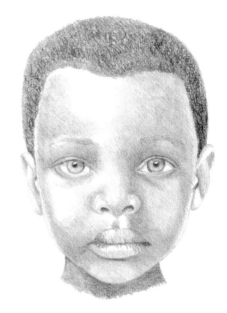

Practise here

If you are working from photographs rather than from life, don't use a flash as this will flatten the appearance of the face. Wherever possible, use gentle, natural lighting and illuminate the face from the side; nothing harsh. If you are using pencils, unless you are working on a large portrait, steer clear of the darkest – that is, anything over 4B – as these could be too heavy. Similarly with charcoal. Also, leave the white of your paper to show through in several areas to convey the glow of light falling on the skin, hair, lips and eyes. It's easier to add tone later than to erase it, otherwise you won't achieve the brightest whites needed for this subject. Try to avoid overworking your portrait. Keep your drawing fresh and light, and leave it just before you think you have finished.

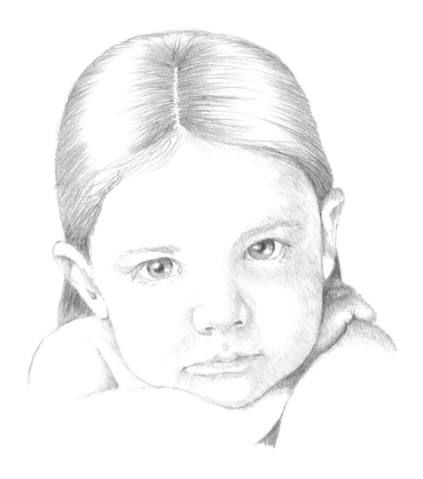

Draw some baby and child faces here

Either copy those in the preceding pages, or draw others.

Older Faces

Everyone ages differently. Some of the effects of ageing can be seen in less plumpness, because under the skin the muscles shrink slightly, fat deposits on the cheekbones reduce and bones lose their density. Throughout life, the nose and ears continue to grow, and as we age, eyebrows lose their definition, the hair thins and turns grey. The skin becomes thinner and jowls may appear as the jawline loses firmness.

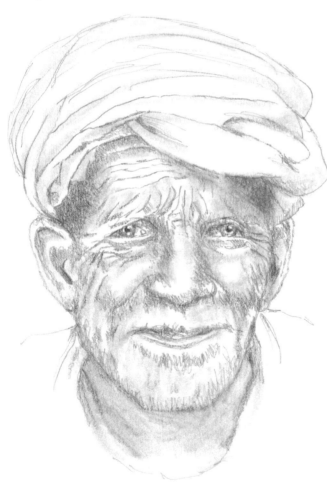

These effects are seen earlier or later in some areas on different people. When drawing an older person's portrait, you don't need to draw every droop or wrinkle, but you need to include at least some of these effects or your portrait will look unrealistic. Convey just an impression rather than too many details, or, unless these are adding character or charm, they could overwhelm the actual face.

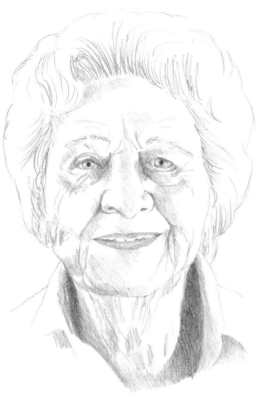

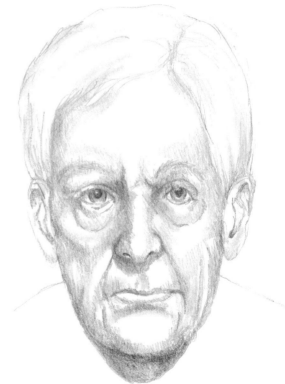

Of course some wrinkles and other changing aspects of the face from youth convey a life lived, experiences and wisdom gained. The main areas you will see lines are furrows on the forehead, crow's feet at the corners of the eyes and 'marionette lines' at the sides of the nose and mouth. Lines around the outside of the eyes and on the cheeks often project a smiley character. Nearly always, the jawline changes slightly – or obviously – as the sharpness softens and the face shape becomes squarer. Lower eyelids bag or sag and upper eyelids droop. Although the tops of the ears do not appear to change, the lobes often extend, as does the bottom of the nose. The lips

lose plumpness and often feature more lines in and around them, and they can tilt slightly downwardly in the corners towards the chin.

This isn't all depressing though! An older face can look kind, especially if there are many smile lines. The eyes often have a cheeky or roguish twinkle, or a sense of depth, knowledge and insight. Loss of or receding hair can make stunning eyes more noticeable, and softer skin on the eyelids can also give a gentleness to the face. Sometimes, the roundness of youth gives way to a leaner, slimmer face shape, and lightening hair can also be more attractive than the heavy, darker hair of previous years. Older people have seen many changes, lived through good and bad, often loved and lost, worked and rested, travelled and read, and drawing them gives us a chance to capture some of their history.

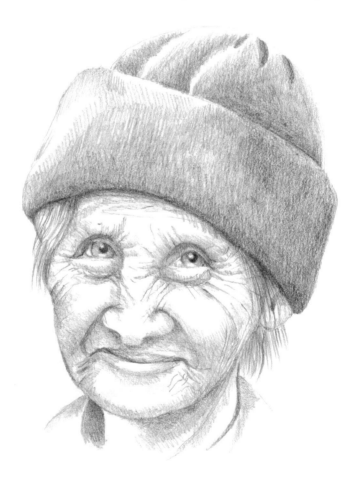

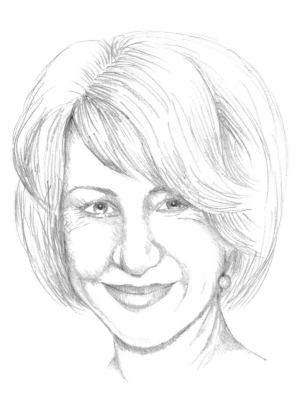

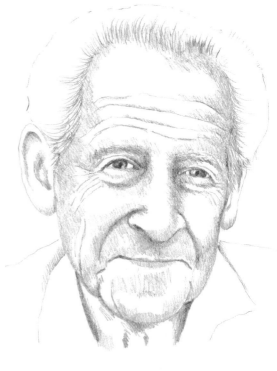

Natural light

Before you begin, really look at the person you are going to draw and see what angles and lighting suits them best. Consider whether or not to include glasses, as these follow fashion and can look dated a few years later. Also, they can reflect the light as the eyes are obscured.

When drawing more mature faces, as with younger faces, avoid including too much definition or too many strong tonal contrasts. Blend away any heaviness. Use a light touch when drawing the features and aspects that have occurred over time, such as hollower cheeks or frown lines between the eyebrows. While eyes may seem smaller, they are often also lighter in colour, with softer tonal qualities – and they're still shiny or sparkly, so include small highlights.

Try drawing your subject from the front or from a slightly oblique position. Sometimes rear or side lighting works well, or sometimes frontal lighting. Natural light is better than artificial, and it should be soft or the sitter will probably squint. Your lighting should not be too intense, so use soft natural light where possible. Lighting from

the side will accentuate wrinkles by creating more shadows as the light travels across the surface of the face. Notice the way in which light falls across the face, which parts are highlighted and which are in the shadows. Shadows on the face should not be too dark or take up too much of the portrait. As with many faces, shadows are usually denser at the corners of the mouth, in and around the nostrils and in the pupils, although often the lines from nose to mouth are also quite dark. Mouths should not be shaded too darkly, and neither should eyelashes.

One of the best things about drawing older people is that they frequently have the ability to stay still for however long it might take you to draw them, so they make great subjects.

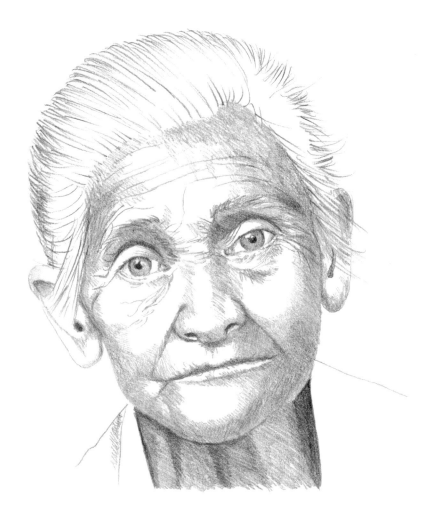

Practise drawing mature faces here

Projects

The drawings in this section of the book are shown in steps from the first to the final marks. The aim is to guide you through the process of drawing them, to show you how simple it is at the start; you just need to take an overall view of the shape of the head and hair, then gradually add or alter elements stage by stage until you reach the point where you can begin shading, or adding tones.

By adding tones, you will make the entire face 'come alive' and look realistic, but you can't move on to this until you are sure your proportions and shapes are correct.

There are a variety of faces in the projects ahead, ranging from a baby to an elderly person; the skin, hair, features and face shapes all differ, and also the angles of the heads and the individual expressions. Some of the projects are less detailed than others, so you might prefer to start with these and build up. The more detailed faces are not more difficult, but simply require more time and concentration – and patience!

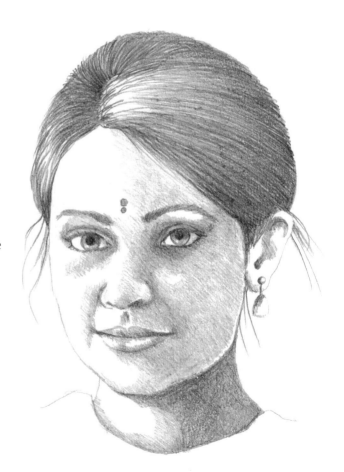

It really is simple when you start; pay close attention not only to the shape of the head and its angle on the neck, but also to the spaces around each head – the negative space. In this way, you will be less subjective and more objective about what (or who) you are drawing. Then, marking on guidelines will help you to place the features. These guidelines can be a mere hint at where the features go; always begin with the central line between the eyes, down the middle of the nose and through the centre of the lips.

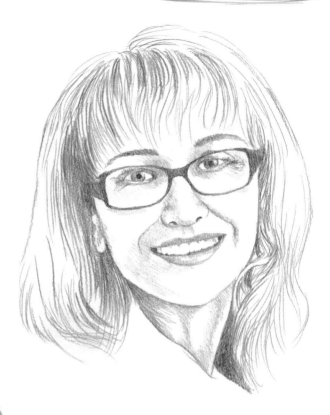

By following these projects and practising in the book itself, as well as on separate paper or in your own sketchbook, you will learn how to draw anyone's face using the same process.

Profile View

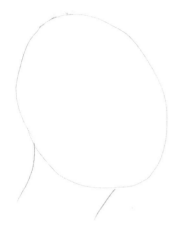

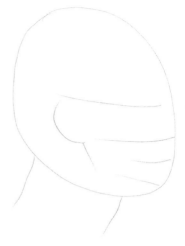

1 *Draw the overall shape of the head and neck.*

2 *Mark on guidelines for the eye, nose, mouth and ear.*

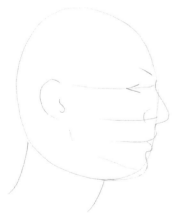

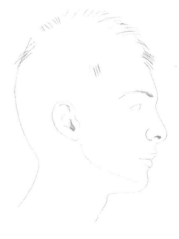

3 *Lightly shape the eye, nose, mouth, ear and chin.*

4 *Begin to draw in the hair, then the features with rounded lines. Shade inside the nostril and ear.*

Practise here

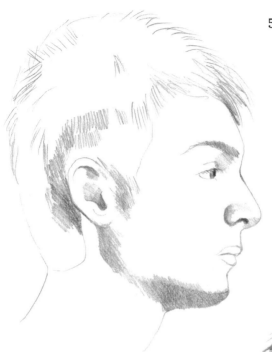

5 *Lightly build up tone and texture, drawing on light lines for the hair, with soft rendering for shadows beneath the chin, around the nose, eye and hair.*

6 *Continue to work across the entire face, layering soft tones and building up the depth of shadows to create a rounded, seemingly three-dimensional image. Leave large areas untouched, so the white of the paper creates the impression of light and highlights.*

Try drawing your own version of this face here

Young Woman

1 *Draw the overall shape of the head and neck, then mark on where the features will be placed.*

2 *Start to shape the head, adding the shoulder, contour of the hair and angle of the hand on the left side of the head (our right-hand side). Lightly mark in the basic shapes of the facial features.*

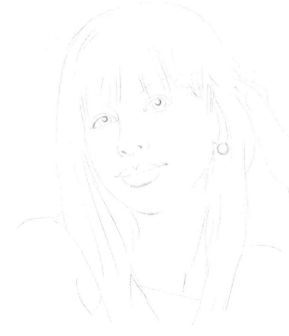

3 *Shape the rest of the head and face; that is, draw in the eyes, nose, mouth, hair, shoulders, neck, hand and earring – just an outline for now.*

Practise here

4 *Once you are comfortable with your light outline drawing, build up some tones using a range of soft pencils. Make sure that the hair is drawn in broken lines in the direction it falls, to create a sense of texture and shine. Use a light touch for facial tones; allow viewers to 'add' their own vision to your drawing by what you leave out. As we draw, we are all naturally selective and we distil information, reducing elements and creating personal interpretations.*

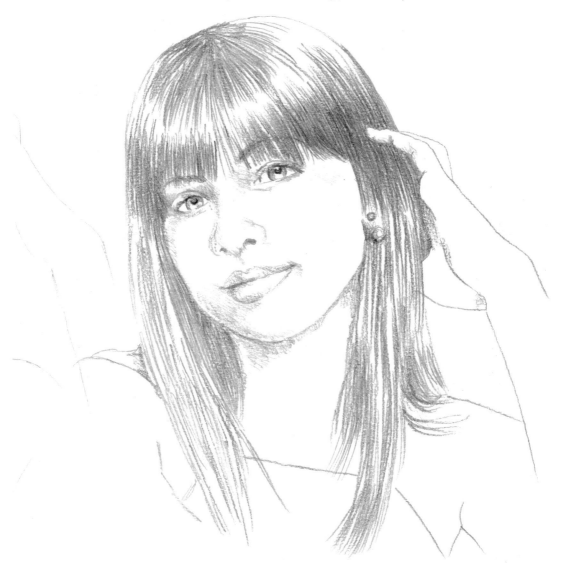

Try drawing your own version of this face here

Older Man in a Turban

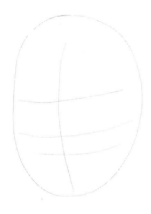

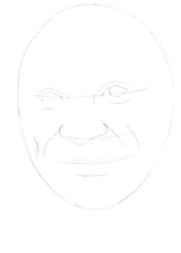

1 Draw an oval to indicate the head. Draw light lines to mark where the features will be placed.

2 Using your guidelines, start to draw the features. Always use a light touch.

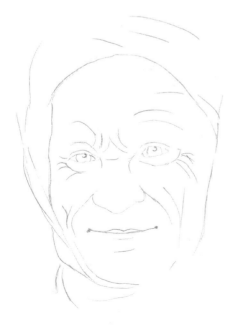

3 Build up the features more carefully and add expression lines. Gradually add lines for his keffiyeh.

Practise here

4 *Now create tonal contrasts using a soft pencil and gentle rendering to create the appearance of shadows and highlights. Some of the shading in this drawing indicates the warmth and depth of his skin colour.*

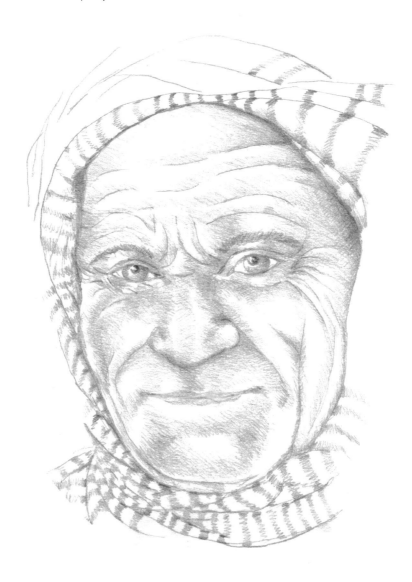

Try drawing the same face here

Baby

1 Draw the lightest guidelines for the shape of the baby's head and mark on with light lines where the features will be placed.

2 Begin to draw the features. Use the lightest touch, so if you make a mistake it can be easily erased.

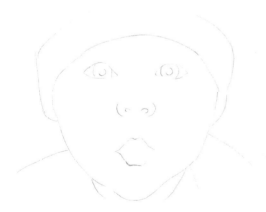

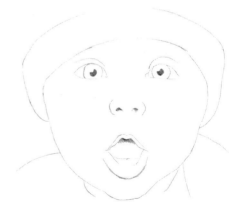

3 As you create the appearance of the facial features – still using a light touch – you can erase your initial guidelines.

4 This baby is being extremely expressive, with wide open eyes and mouth. Baby features are larger on their faces than adult features, as their heads are smaller. Mark on the edge of the hat.

Practise here

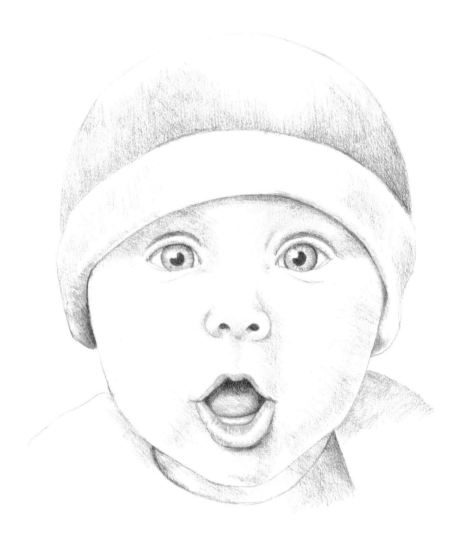

5 *Once you are content with your outline drawing, use a soft pencil (but not too dark) to blend in the lightest suggestion of shadows. Work across the face rather than concentrating on one area, in order to achieve a balanced image.*

Try drawing your own version of this face here

When you have practised, draw the face again on separate paper, and then try drawing another baby's face.

Three-quarter View

1 *The three-quarter facial view was a favourite of Renaissance artists. It's not the easiest because through perspective, the part of the face furthest away from you is slightly smaller than the part that's closest to you. Begin with the basic shapes of this woman's three-quarter profile. Don't worry about details; just observe and draw the outer contours as you see them.*

2 *Draw guidelines for where you will place the eyes, nose, mouth and ear.*

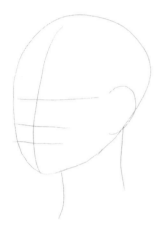

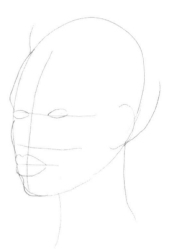

3 *Using a light touch, mark on the shapes of the features.*

4 *Shape more of the hair, chin and ear, and lightly build up the actual shapes of the features.*

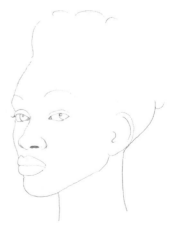

Practise here

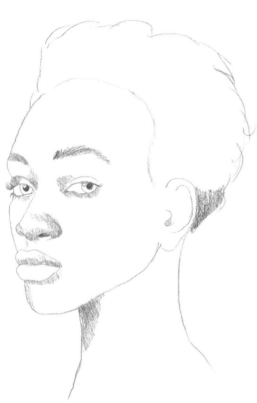

5 *Build up the eyebrows and shape of the hair, and add details to the eyes, nose and lips.*

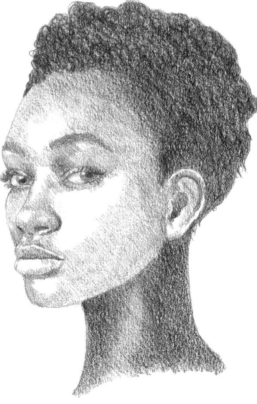

6 *Because this is a black and white drawing, the skin is represented as a combination of local tone and the pattern of light and shadow falling on the face. Leave areas of the white of the paper bare to convey a sense of highlights.*

Try drawing this face here

Once you are happy with it, draw the same face again on separate paper or in a sketchbook. The more you draw, the more accomplished you will become.

Smiling Woman

1 *Teeth can be a bit daunting at first, but when treated as simply part of the mouth rather than individual items, you will find that they work. Begin this drawing with the shape of the head and shoulders.*

2 *Add guidelines for the facial features and mark on some of the contours of the hair. Ignore the teeth at this point.*

3 *Lightly begin to draw the features – you are getting a feel for where they will be placed and their sizes in comparison to each other.*

4 *Erase the guidelines and shape the features more carefully. Draw the line of the bottom of the teeth as part of the mouth. Don't draw each tooth individually.*

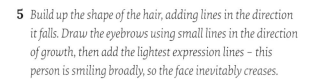

5 *Build up the shape of the hair, adding lines in the direction it falls. Draw the eyebrows using small lines in the direction of growth, then add the lightest expression lines – this person is smiling broadly, so the face inevitably creases.*

Practise here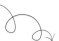

6 *Begin to add shading around the features. The white of the paper will be your highlights.*

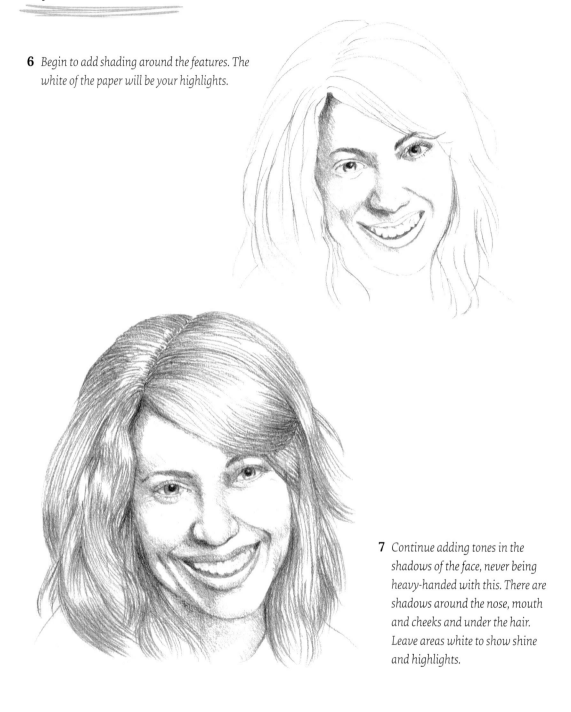

7 *Continue adding tones in the shadows of the face, never being heavy-handed with this. There are shadows around the nose, mouth and cheeks and under the hair. Leave areas white to show shine and highlights.*

Try drawing your own version of this face here

Afterwards, draw another on a separate sheet of paper. Self-portraits are useful ways of learning to draw faces; try propping up a mirror and drawing what you see.

Blonde Woman

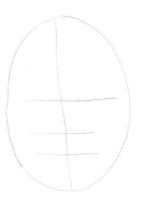

1 Outline the oval shape of the head, then mark on roughly where the features will be placed.

2 Start to shape the outline of the wavy hair and jawline, then add the ear that can be seen under the hair and facial features.

3 Continue building up lines in the hair in the direction of growth, then shape the features more carefully. Add outlines for the neck. Erase your initial guidelines.

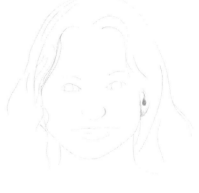

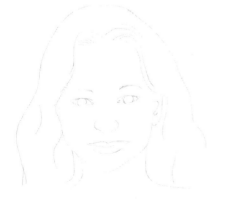

4 Carefully shape the features and build up the layers in the hair. You should end up with the face as an outline with few signs of tone at this point, so it looks like a flat face. The next stage is to start creating a sense of texture and tones.

Practise here

5 *The secret to lifelike hair is drawing lines where there is shadow and leaving the paper showing through for highlights. Gradually and lightly add tones, building up the eyes, nose, lips and eyebrows.*

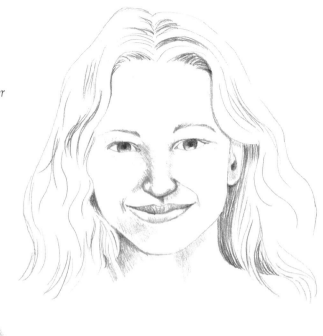

6 *Finish the drawing using a range of soft pencils, such as a 2B, 3B and 5B. Keep the pencils sharp and use light pressure; you can always layer for deeper, darker tones. Be particularly light-handed on the face. Use hatched lines where you need deeper tones on the skin – these will never be too dark as the skin is light, but under the hair where the shadows are darkest, use your softest pencil and layer in the direction of growth.*

Try drawing your own version of this face here

Then draw it again in a sketchbook or on a separate piece of paper.

Young Man

1 *Lightly draw a rough oval shape to indicate the head. Mark on light guidelines for where you will place the features and add two lines for the neck.*

2 *Shape the head, add a contour for the hair and curves for the neck, then begin to draw the features.*

3 *As you continue to shape the features, erase the guidelines. You should end up with outlines for the face shape, features and hair, with no tones yet.*

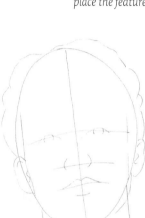

4 *Once you are happy with the proportions and shapes of the features, start to build up soft tones.*

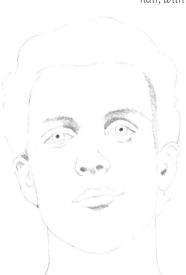

Practise here

5 *Continue to add tones, building in darker layers in the hair (using a softer pencil, such as a 6B) and using a light touch all around the face, in the eyes, ears, lips, under the chin and on the sides of the cheeks. Leave plenty of white paper showing through for highlights and leave a tiny spot of white in the eye for shine.*

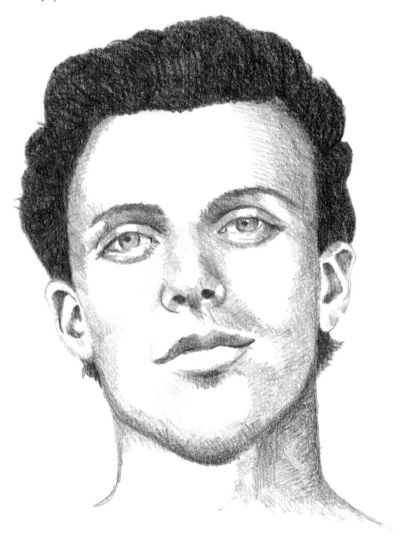

Try drawing your own version of this face here

Continue to draw faces like this whenever you can, paying attention to angles, shapes and tonal contrasts.

Boy

1 To draw this smiling boy, begin with the outline of his head, add two lines for the neck and guidelines for the position of the features.

2 Begin to shape the hair and neckline, and lightly draw the features.

3 Shape the boy's neck, mark on his collar, and continue drawing the features. Erase your earlier guidelines.

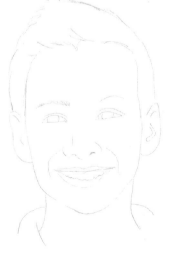

4 Carry on in the same way, adding shape to the hair, eyebrows and other facial features.

Practise here

5 *The most time-consuming part of the drawing is the shading, so begin this knowing that you will need a light touch and patience. Work across the drawing, not dwelling on any one particular area, and draw the hair using small marks in the direction it grows. Squint your eyes to see where the darkest parts are in the hair.*

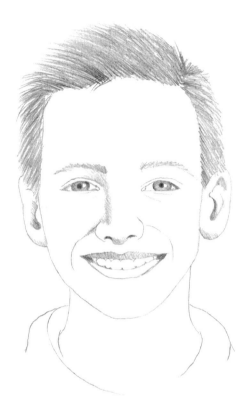

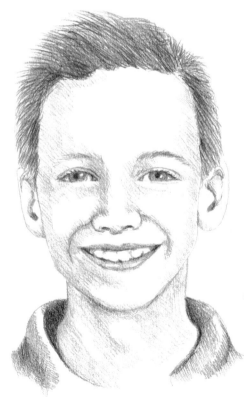

6 *Soft shading is achieved by the lightest touch of your pencil and gentle layering. As this is a child, don't use the darkest pencils; instead, build the darkest shadows in the drawing with a 3B, and the mid-tones with a B or 2B. Leave the white of the paper showing through for highlights.*

Try drawing your own version of this face here

Whenever you can, study faces of people of all ages and notice where the shadows and highlights fall.

Woman in a Hijab

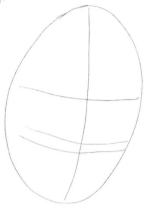

1 Begin with a simple oval for the head. Mark on guidelines for where you will place the features.

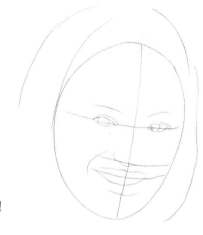

2 Draw the shape of the hijab around the woman's head. Start to outline the facial features.

3 Continue drawing the facial features and once you are confident that these are in the correct proportions and places, erase your guidelines.

4 Build up some creases, folds and draping in the hijab and 'firm up' the features.

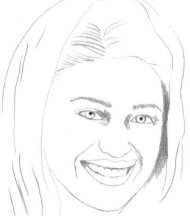

Practise here

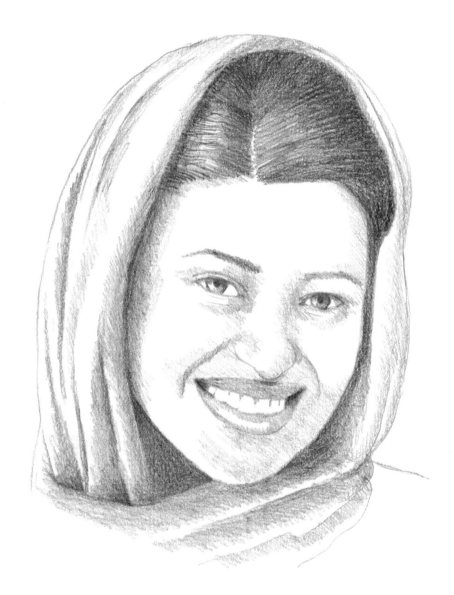

5 *Now take your time building up shading; this includes the shadows on the face, around the features, under and in the hijab and the depth and shine of the hair. Use smooth rendering on the skin and hatched lines in the hair.*

Draw your own version of this face here

Afterwards, draw another face in a similar pose, either in a sketchbook or on a separate piece of paper.

Laughing Man

1 Draw an oval for the man's head and
 mark on guidelines for the features. This
 man's hand is in front of his mouth, so
 add a simple oval for his hand with lines
 coming off for his fingers.

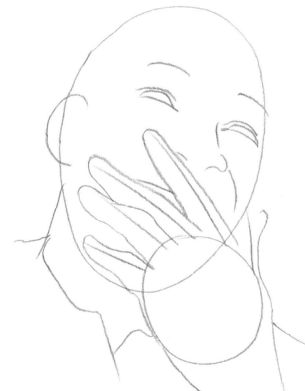

2 Draw the features and 'flesh out' the
 hand. Erase your guidelines as you work.

Practise here

3 *Build up the features, the hand and the tones on the man's skin. Leave white paper showing through for highlights.*

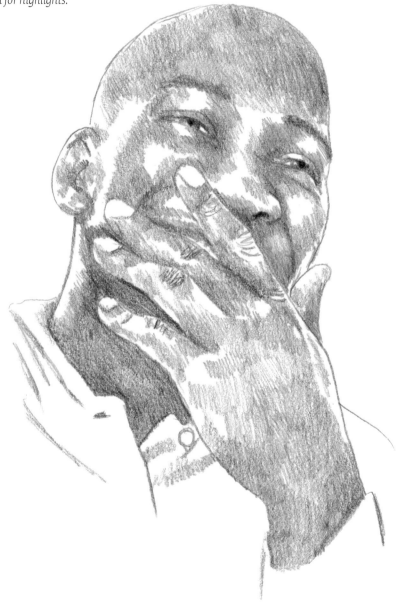

Draw this face in your own style here

Man with Glasses

1 *Draw an oval for the man's head. He is almost in a three-quarter view, so your central vertical line will be slightly towards the side of the face.*

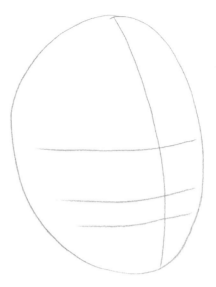

2 *Begin to build up the features. The eyes are covered by glasses and the chin is resting on the right hand.*

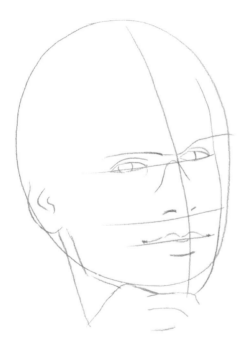

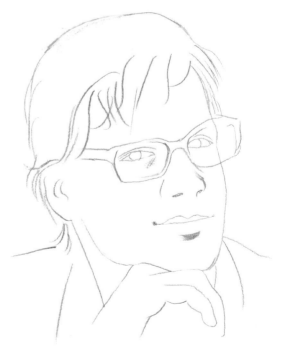

3 *Work across the entire face, building up the features and the man's glasses, then erase your initial guidelines.*

Practise here

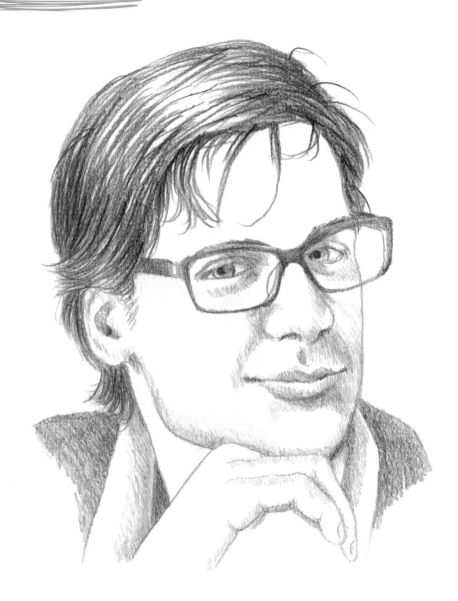

4 *Slowly and carefully add shading to show different effects of light, tonal qualities, colours and reflections. Take your time and look at the face you are drawing more than you look at your drawing. This is the pattern to follow when drawing any face.*

Draw your own version of this face here

Practise some more portraits here

Index